BERTIE MAKES A FRIEND COLORING BOOK

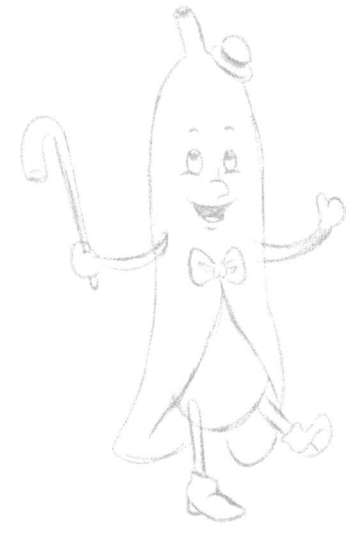
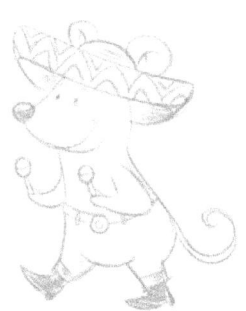
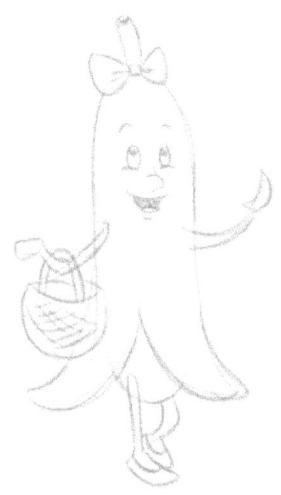

Copyright © 2016 Michael Gomes

All rights reserved.

ISBN-10: 1537560425

ISBN-13: 978-1537560427

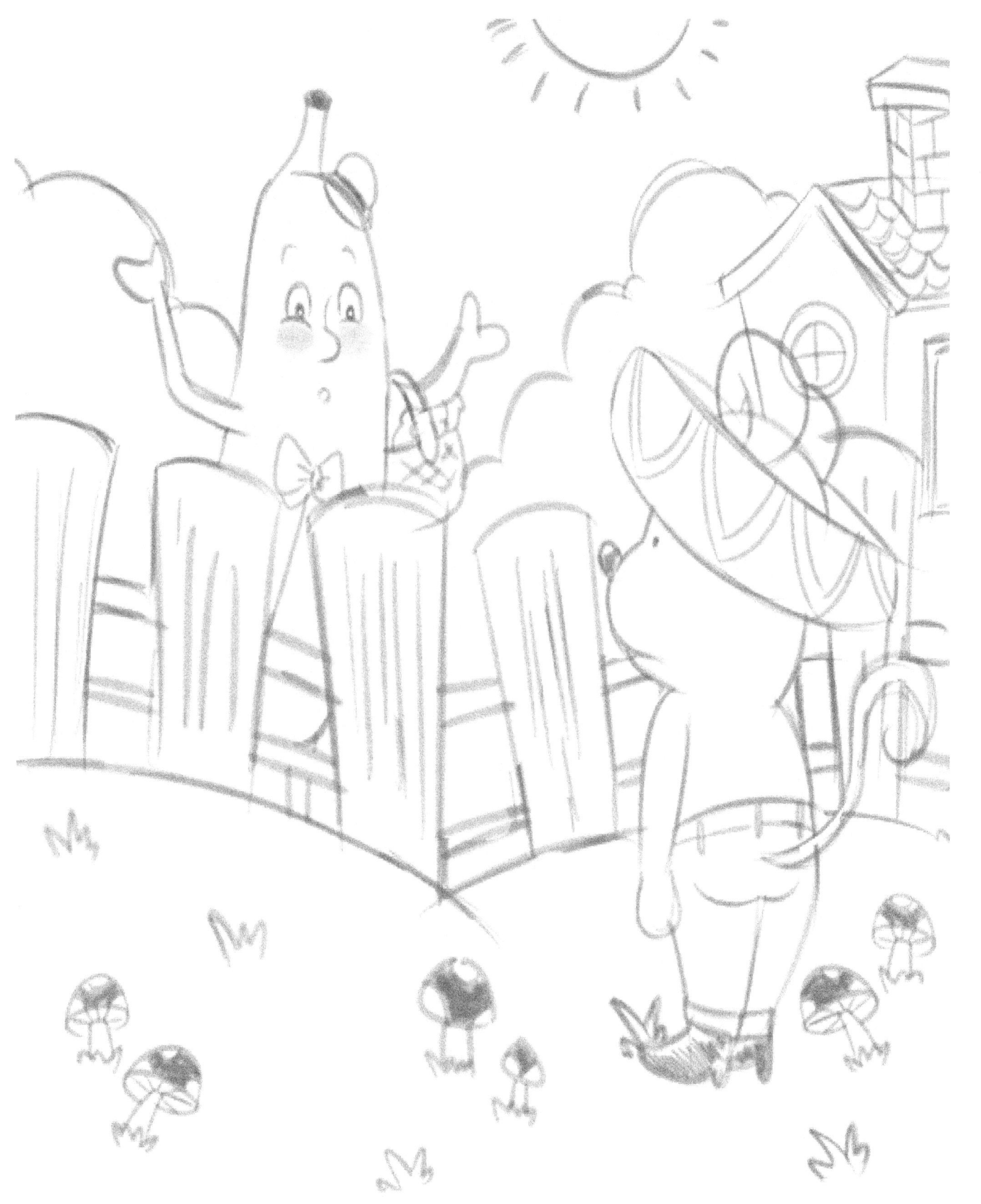

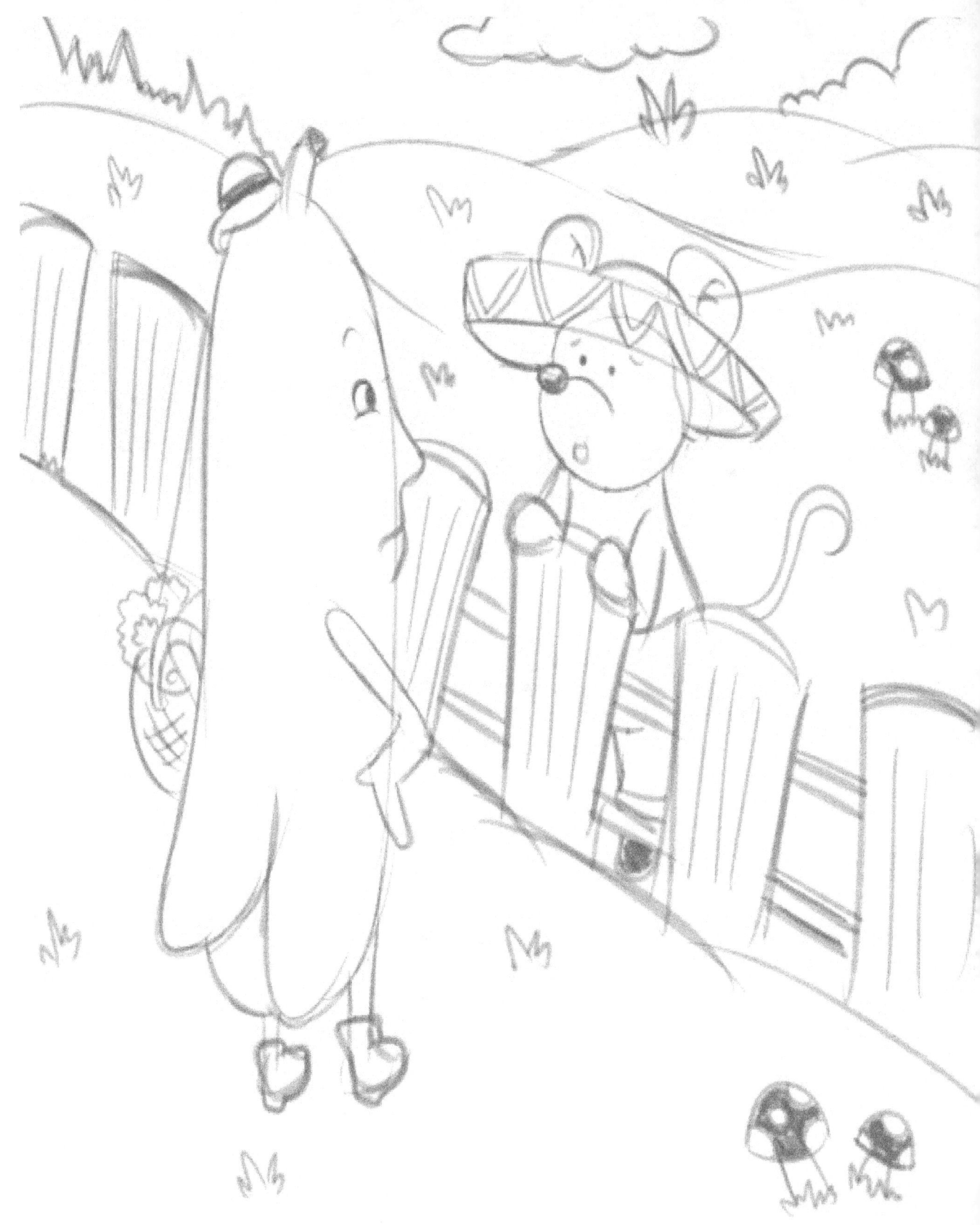

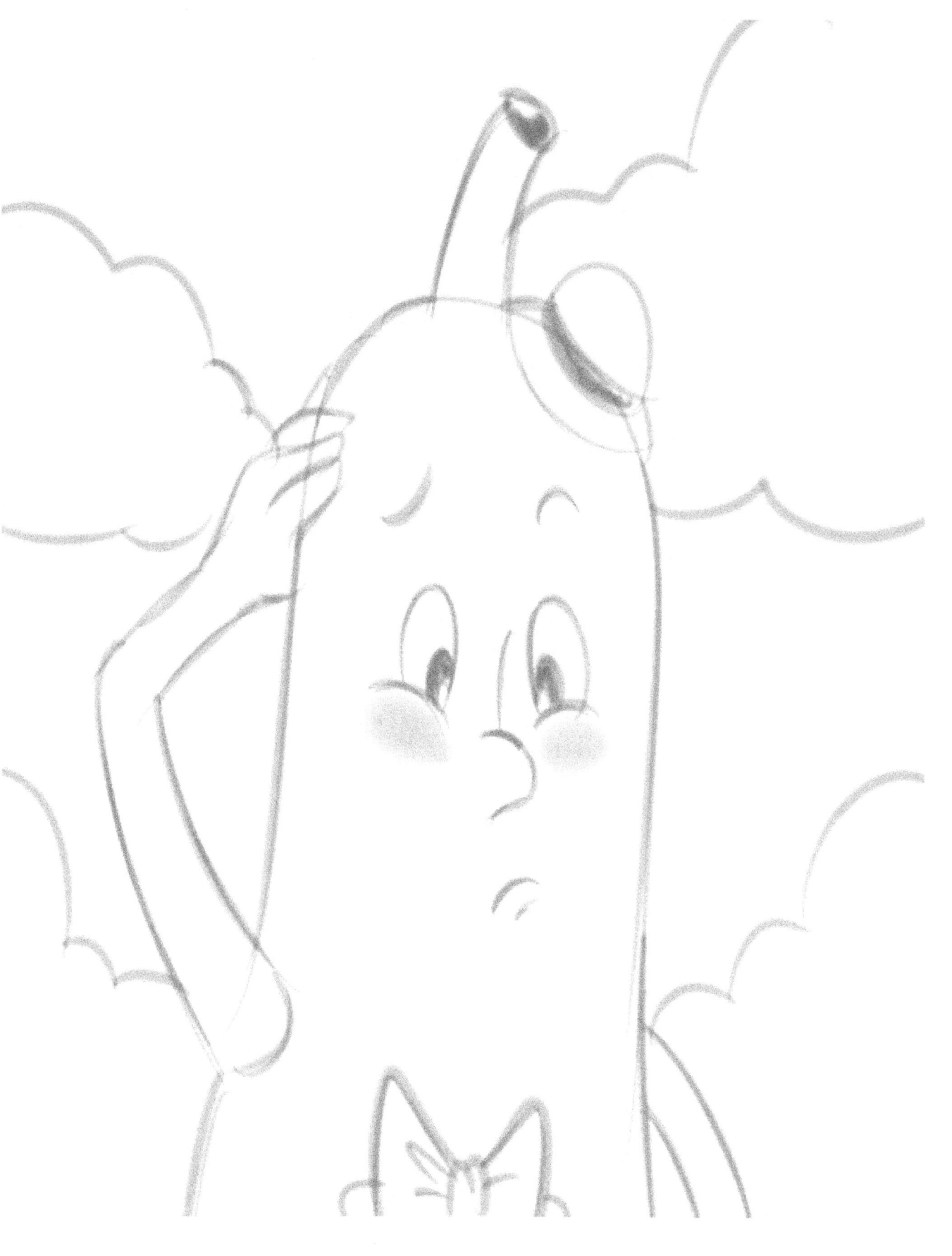

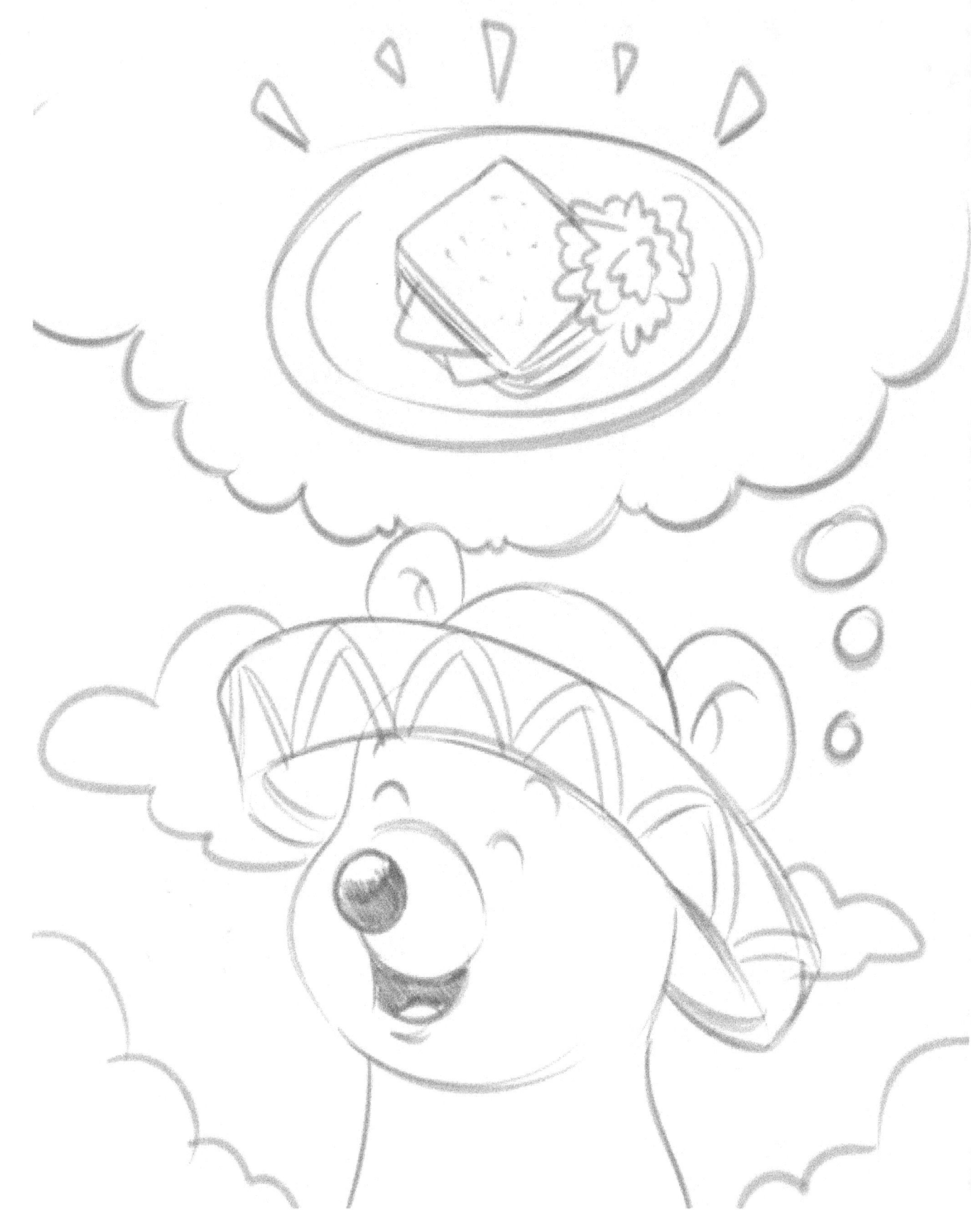

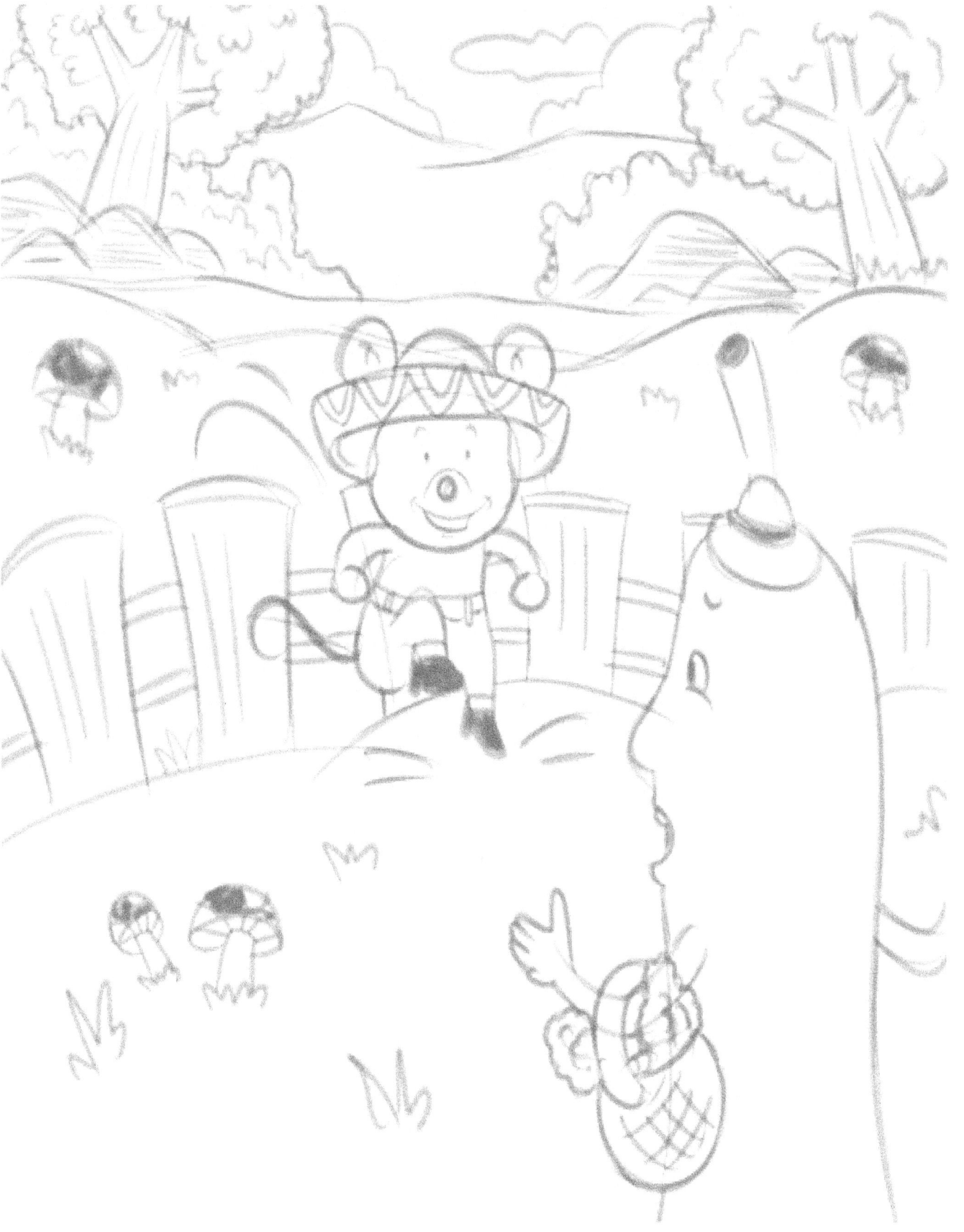

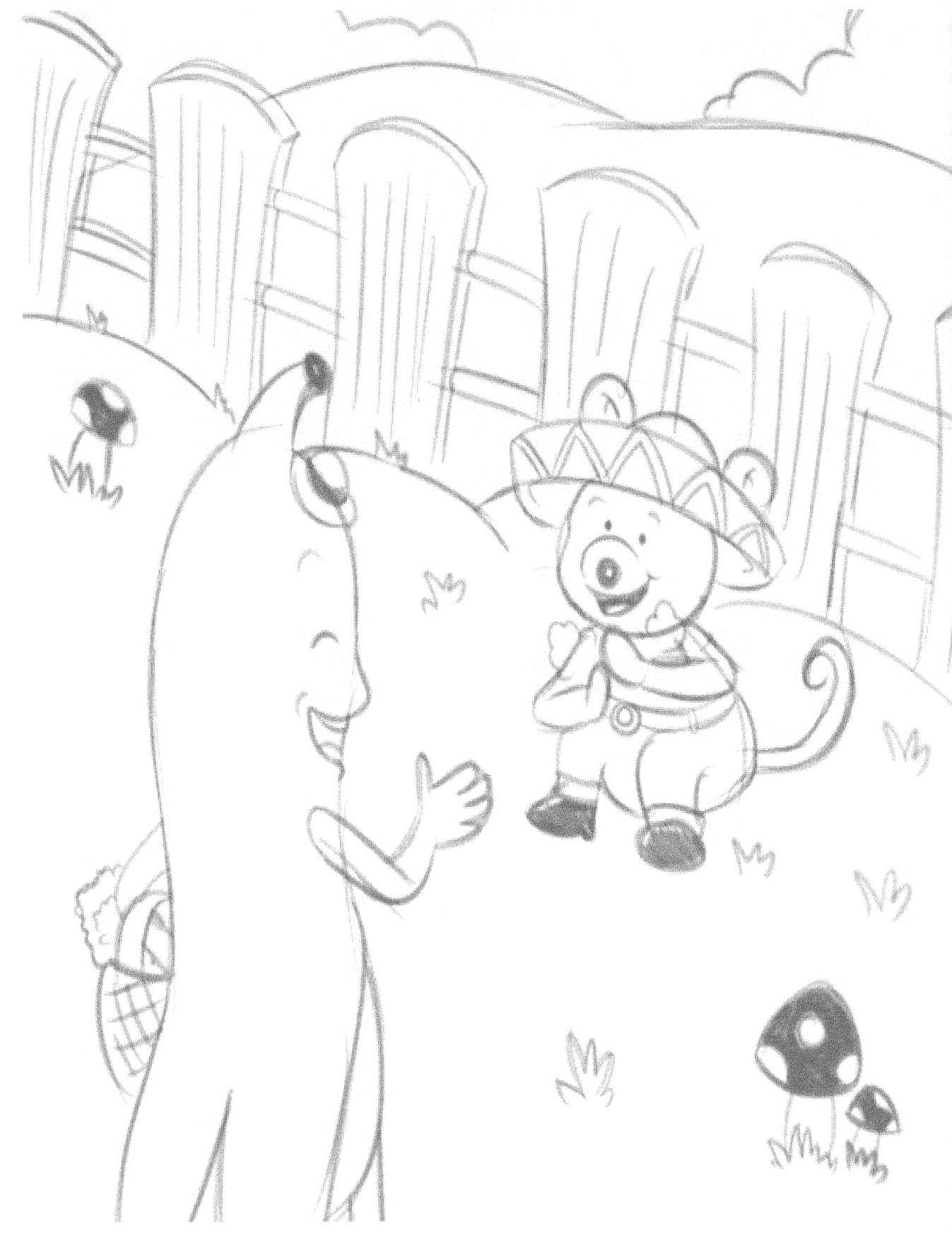

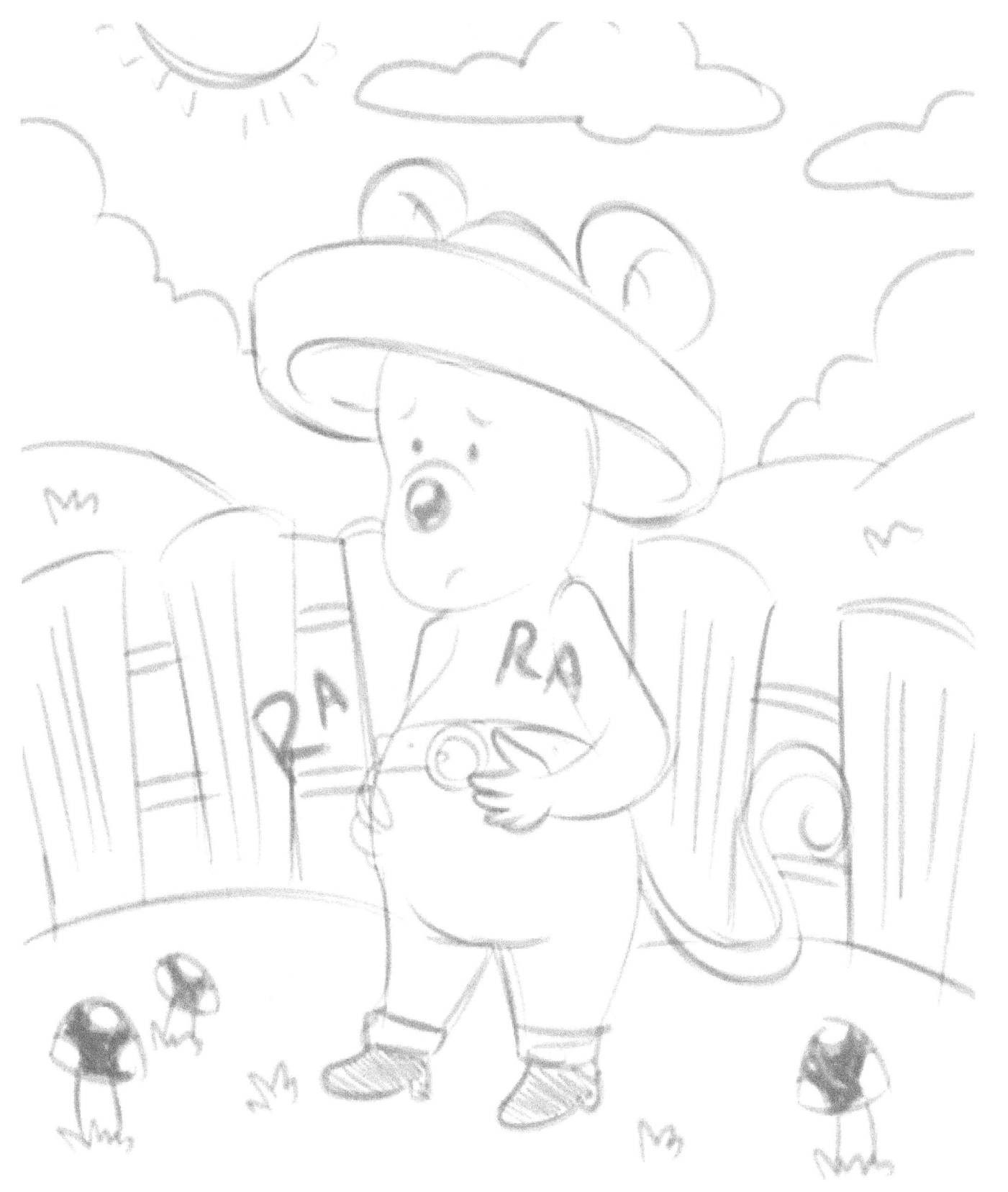

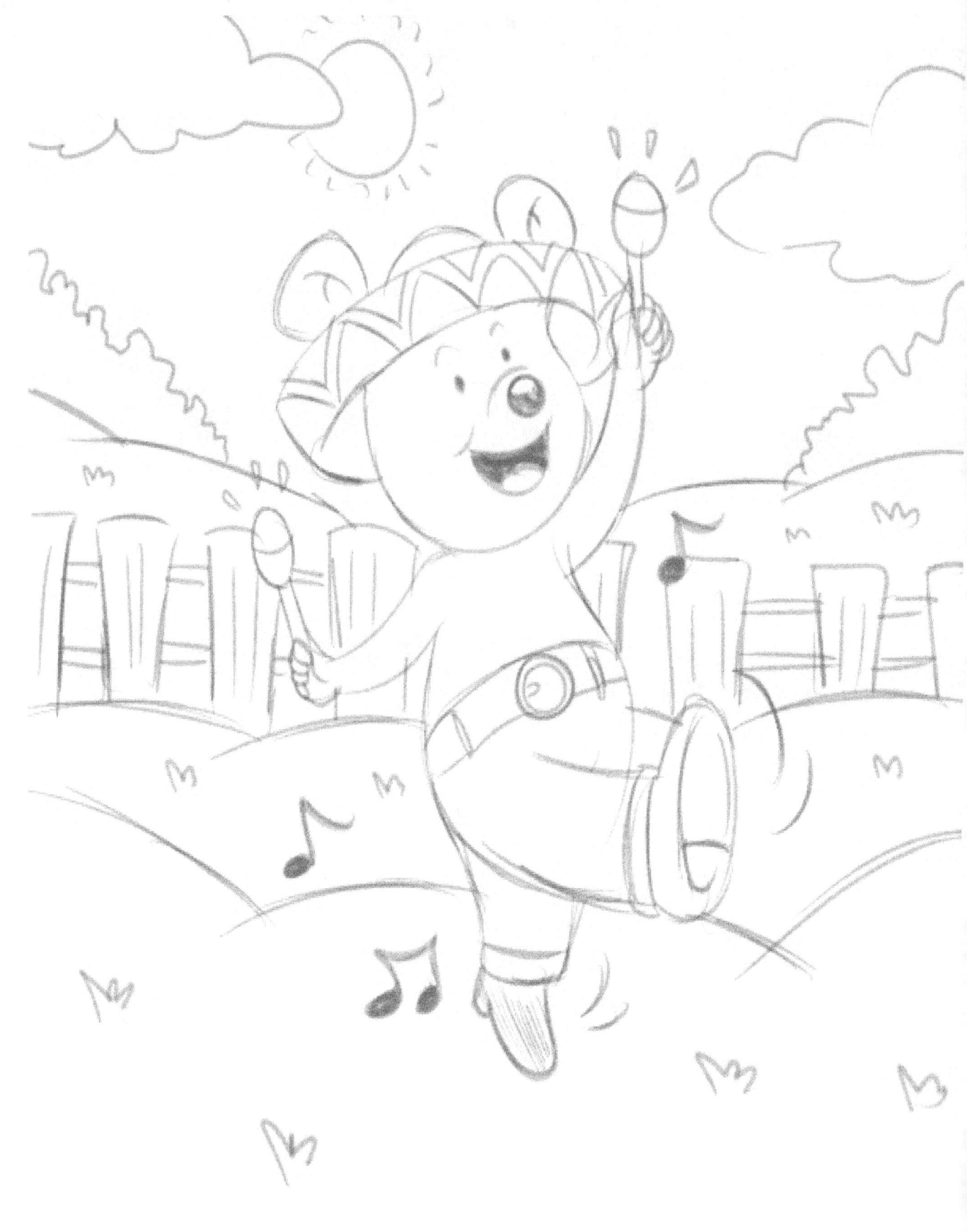

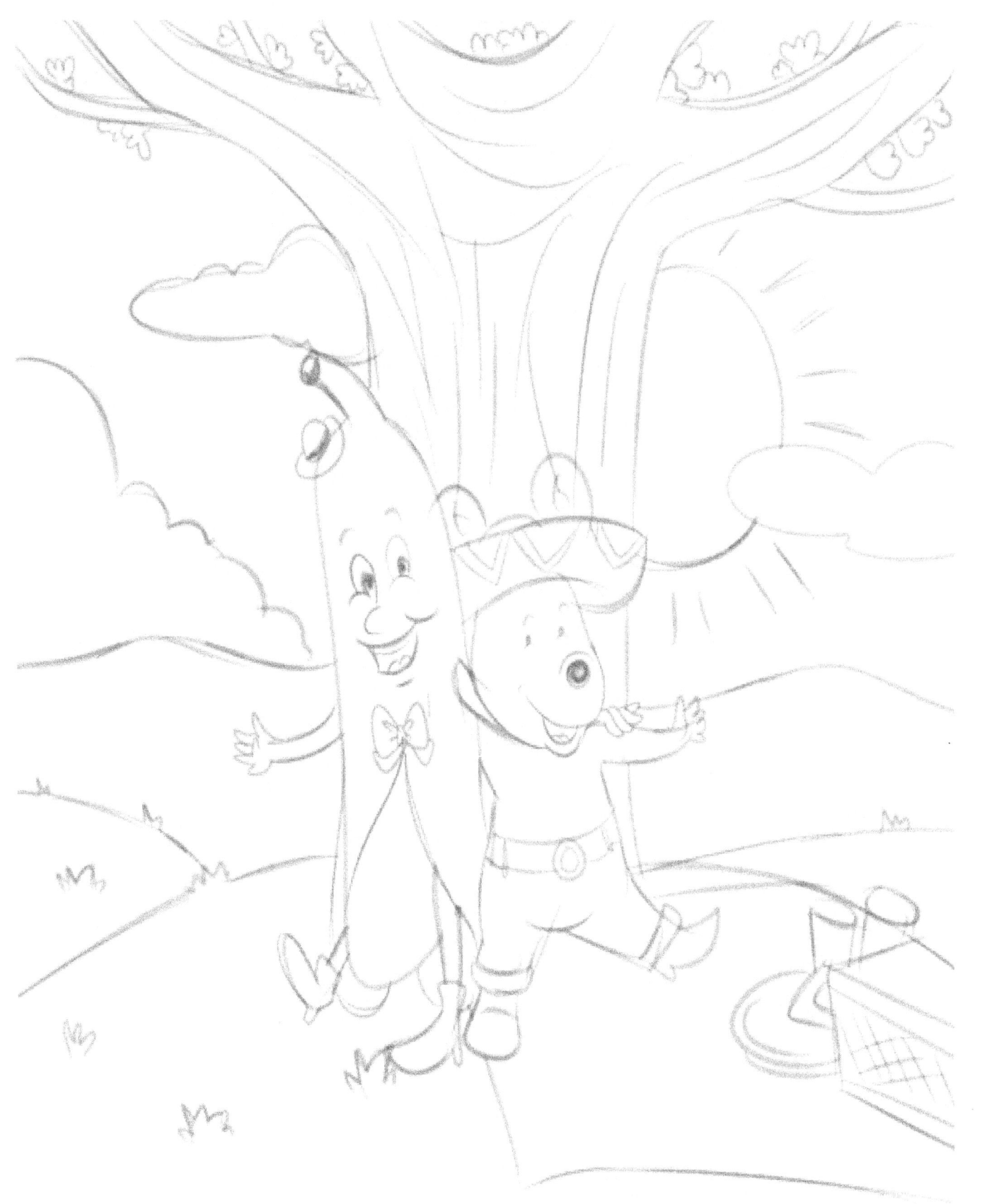

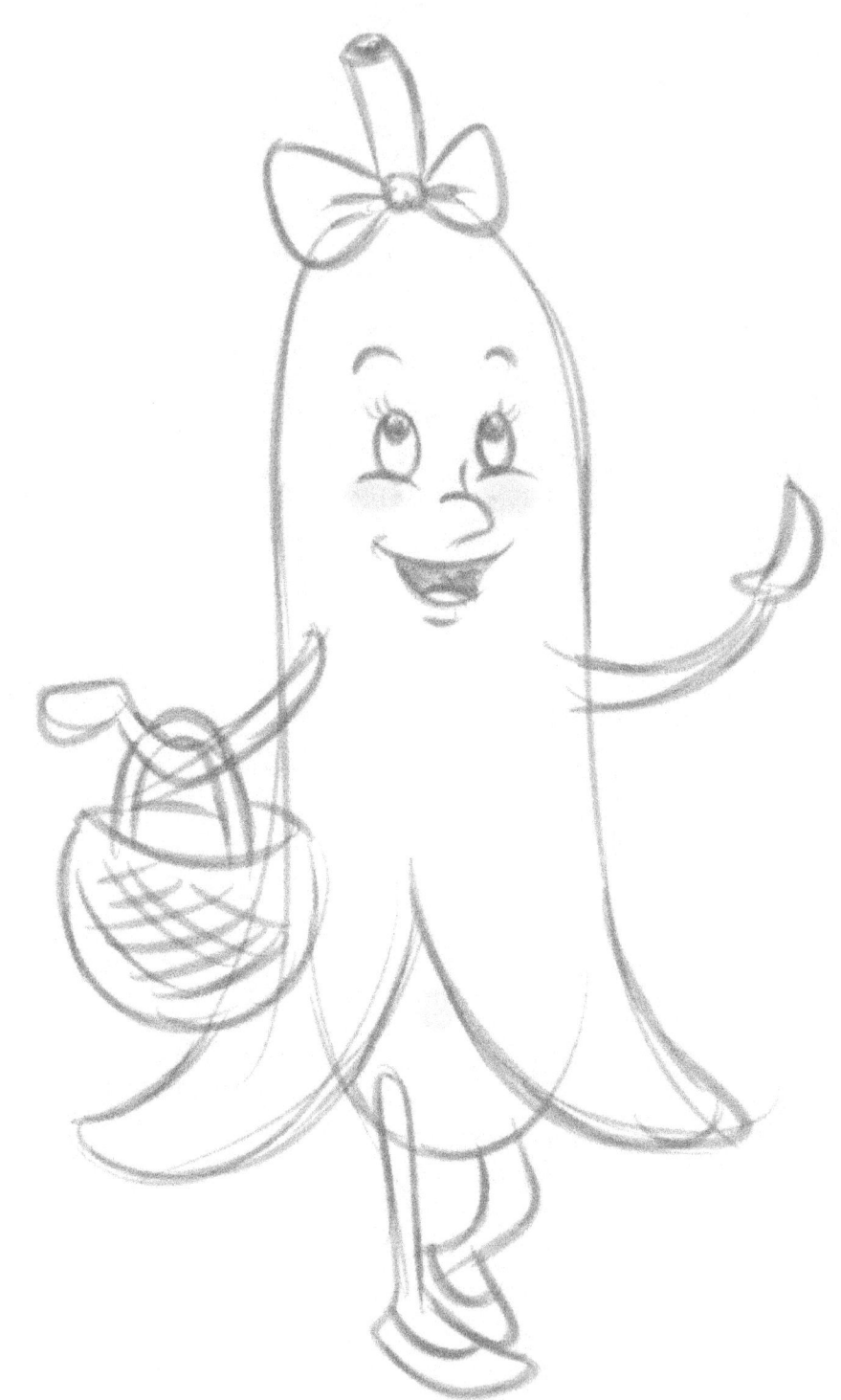

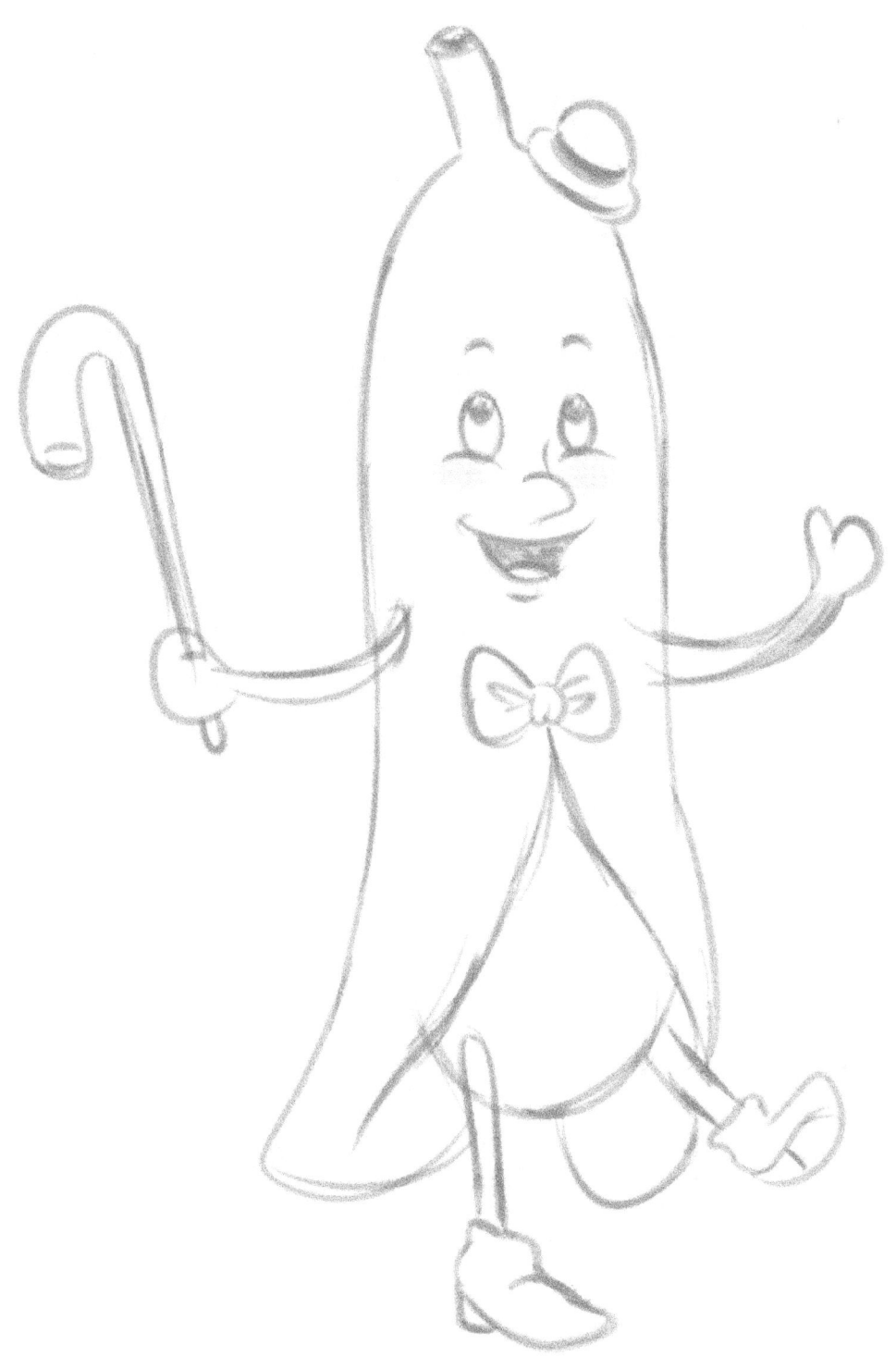

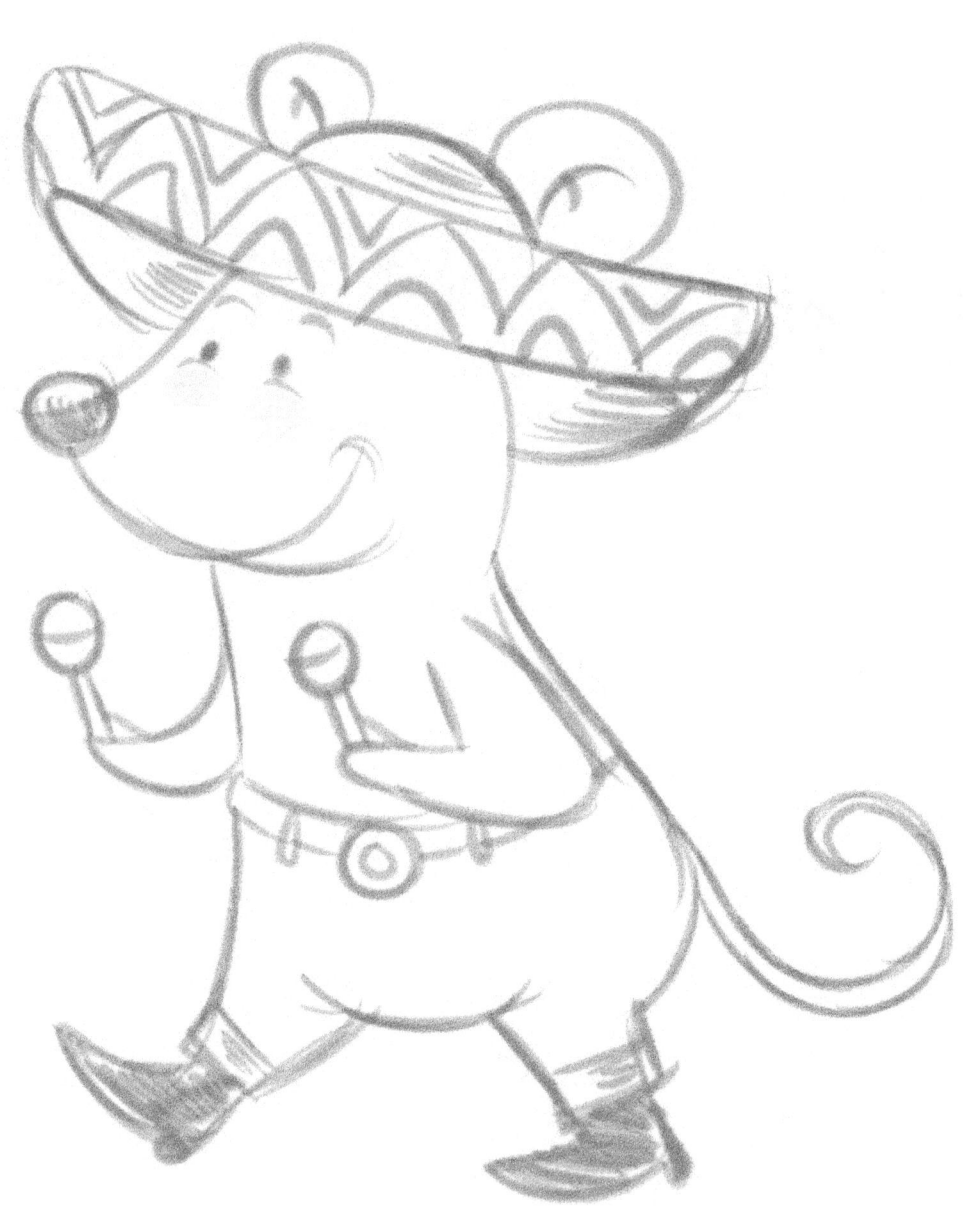

www.ingramcontent.com/pod-product-compliance
Lightning Source LLC
Chambersburg PA
CBHW080534190526
45169CB00008B/3156